A, B, See?
art posing as an alphabet book

by Joel Schoon Tanis

Printed in the United States of America

First Printing, 2014

ISBN 978-0-692-32911-5

Centennial Park Press
17 West 10th Street
Suite 130
Holland, MI 49423

www.CentennialParkPress.com

To my inspiring girls —
Kathy, Harper, and Beatrix.

With special thanks
to the family of
Centennial Park Studios.

A is always for **apples**.

Alligators **a**te
the **a**rrogant **a**pples.

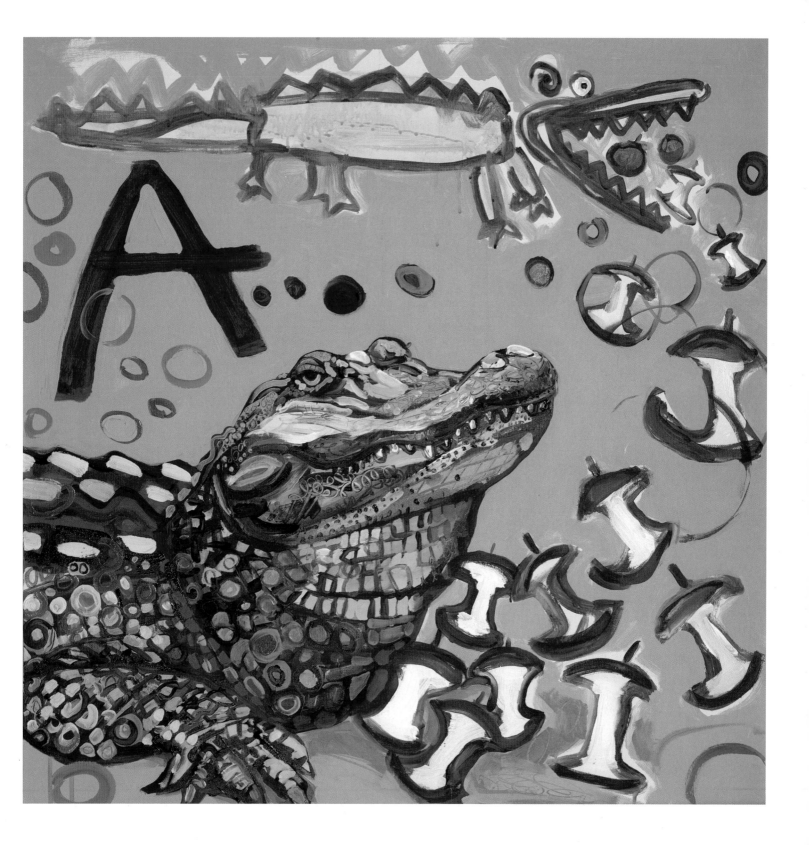

He's **b**are!

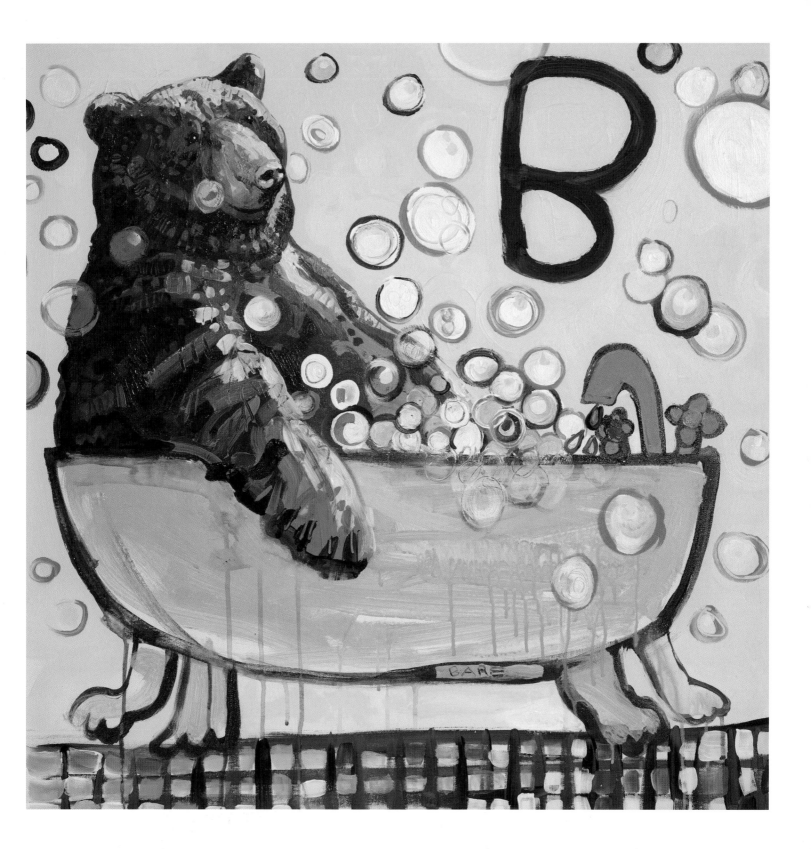

See the **c**-**c**ow?

BUT THAT'S A MANATEE! AH! I C – I MEAN, SEE – SOME LAND-LUBBERS CALL THEM SEA COWS! SEE?

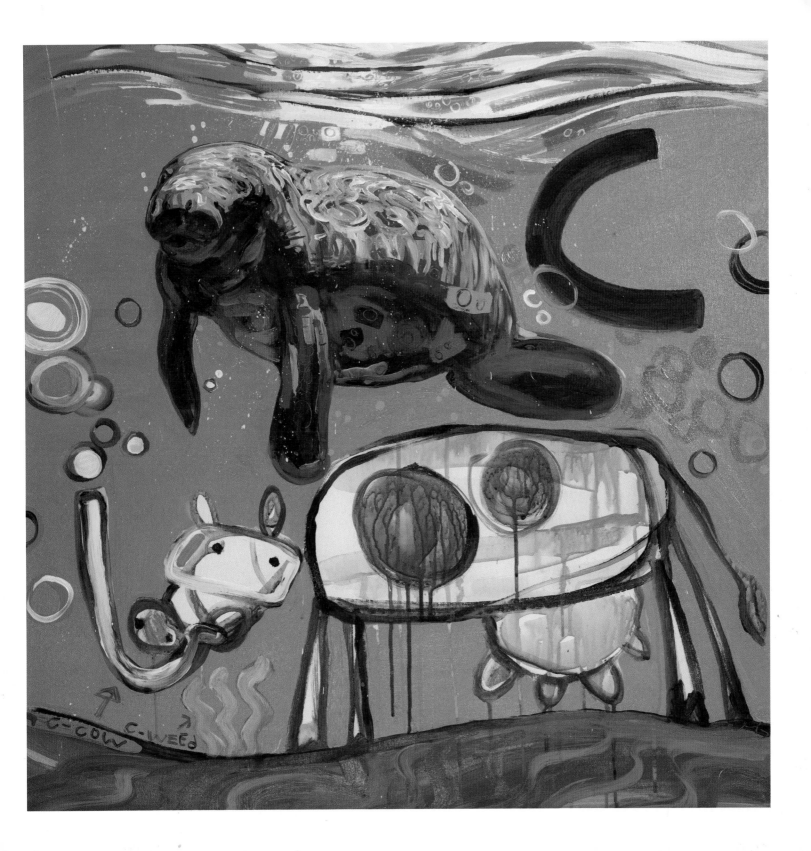

Those **d**ogs smell!

HEAD OVER TO THE LETTER B AND WASH THOSE DOGS! AND THAT MANGY CURRR TOO!

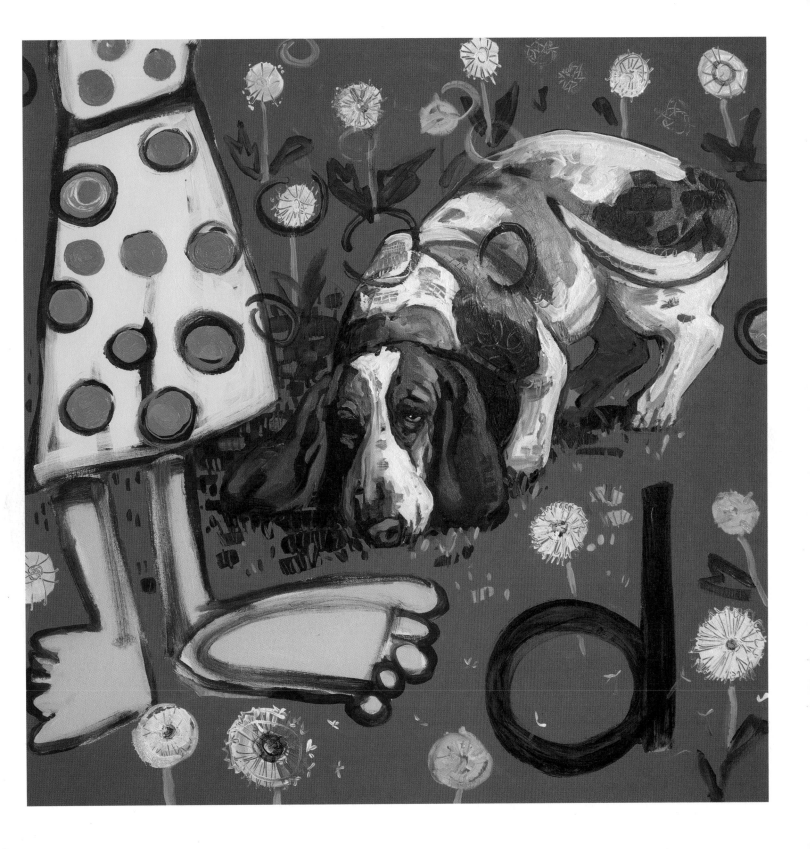

That **e**agle is
pretty **e**arnest
about keeping an **e**ye
on those **e**ggs.

HEY EARNEST – I THOUGHT I JUST SAW THE EASTER BUNNY. WHERE'D HE GO?

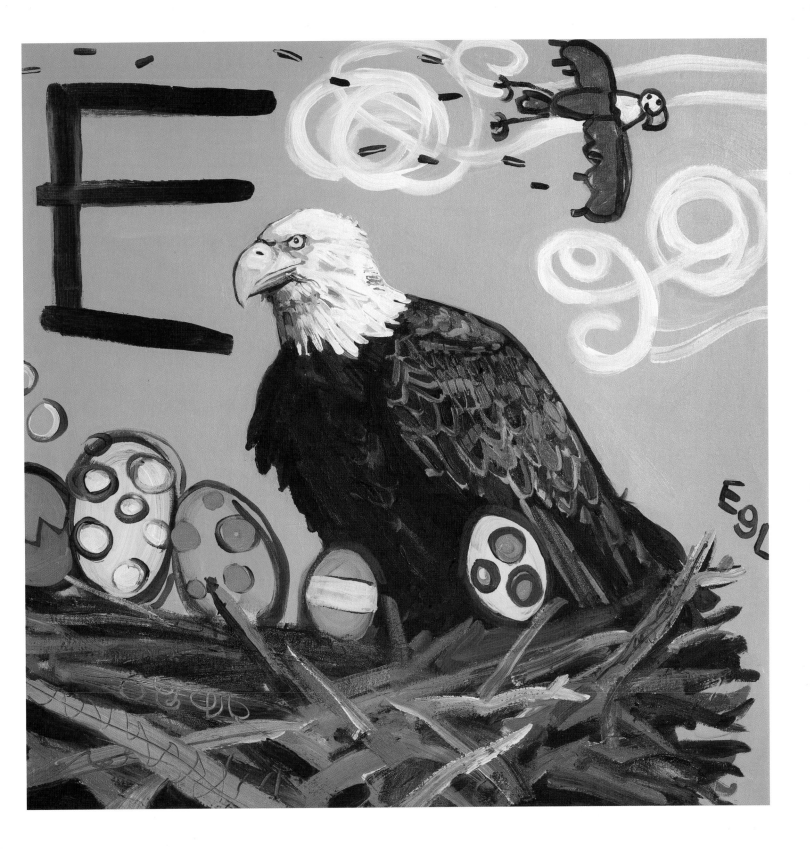

It's **f**un to **f**ind
flamingos dancing
(probably in **F**lorida).

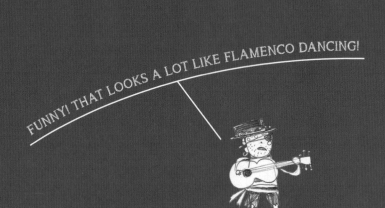

FUNNY! THAT LOOKS A LOT LIKE FLAMENCO DANCING!

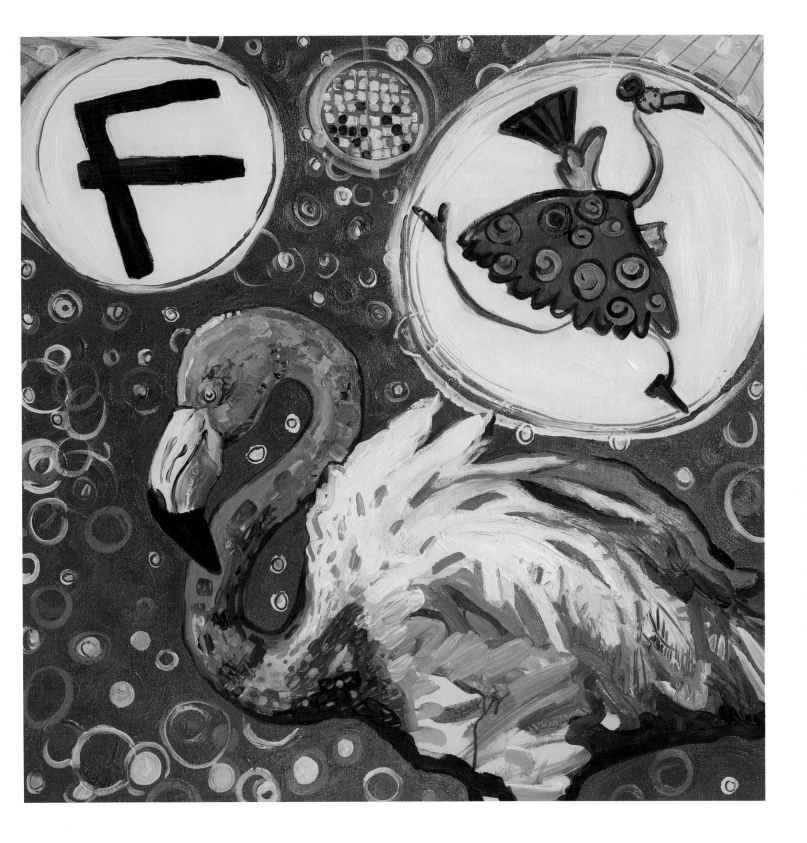

Gnus watching the **g**news **g**nawing on **g**noodles.

GEE! THAT GOT A LITTLE GIMMICKY!

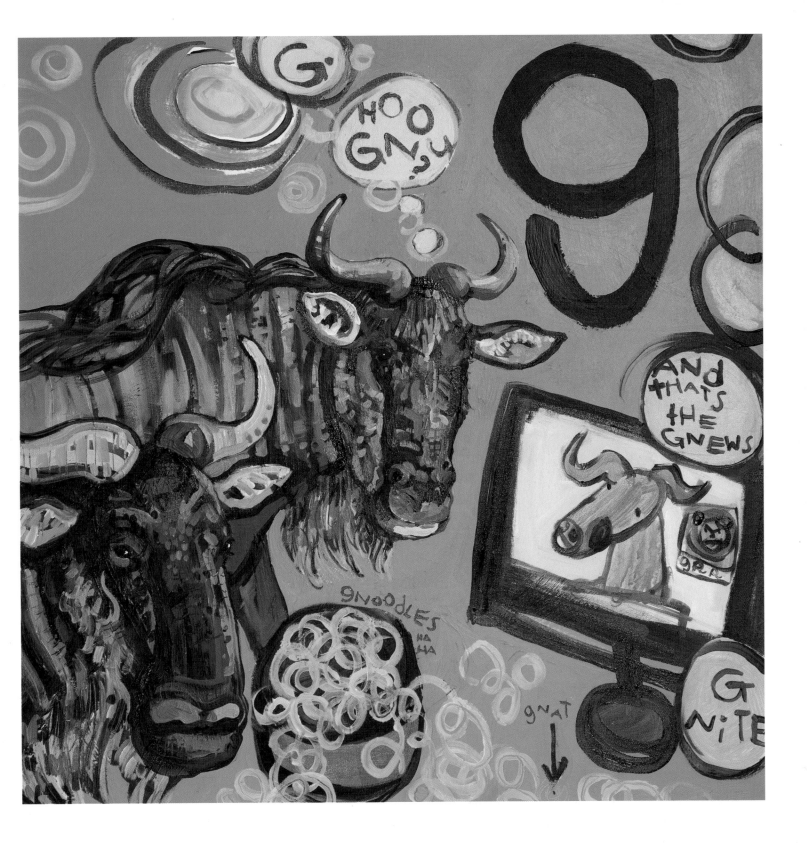

Hippos are called hippos because they have big hips.

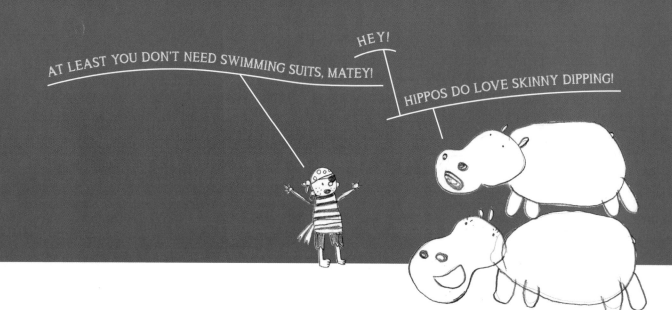

AT LEAST YOU DON'T NEED SWIMMING SUITS, MATEY!

HEY!

HIPPOS DO LOVE SKINNY DIPPING!

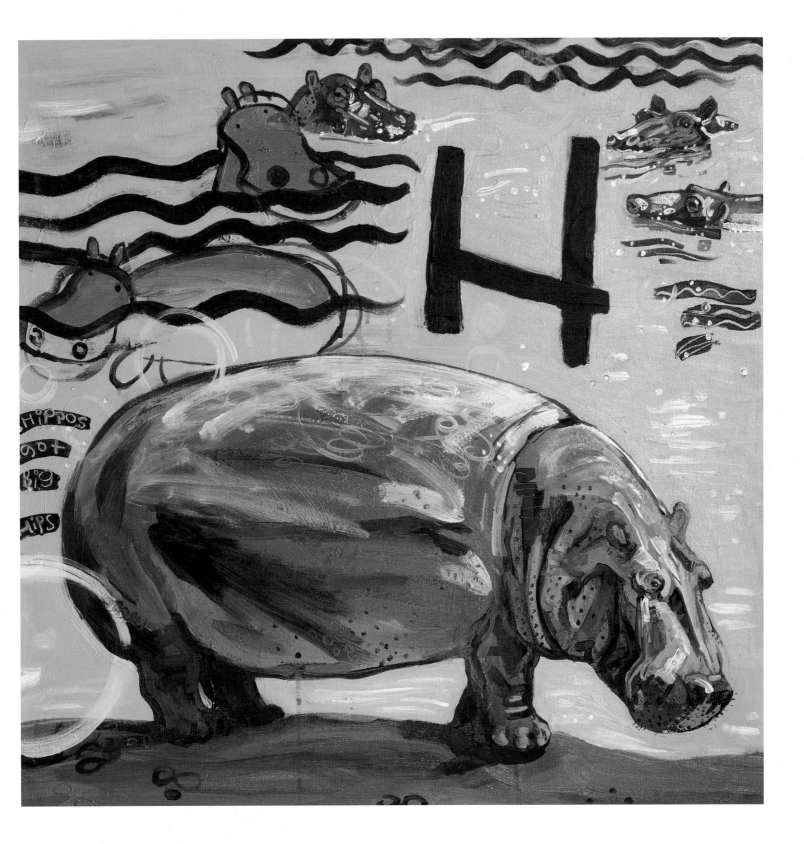

Iguanas have some
buggy looking eyes.

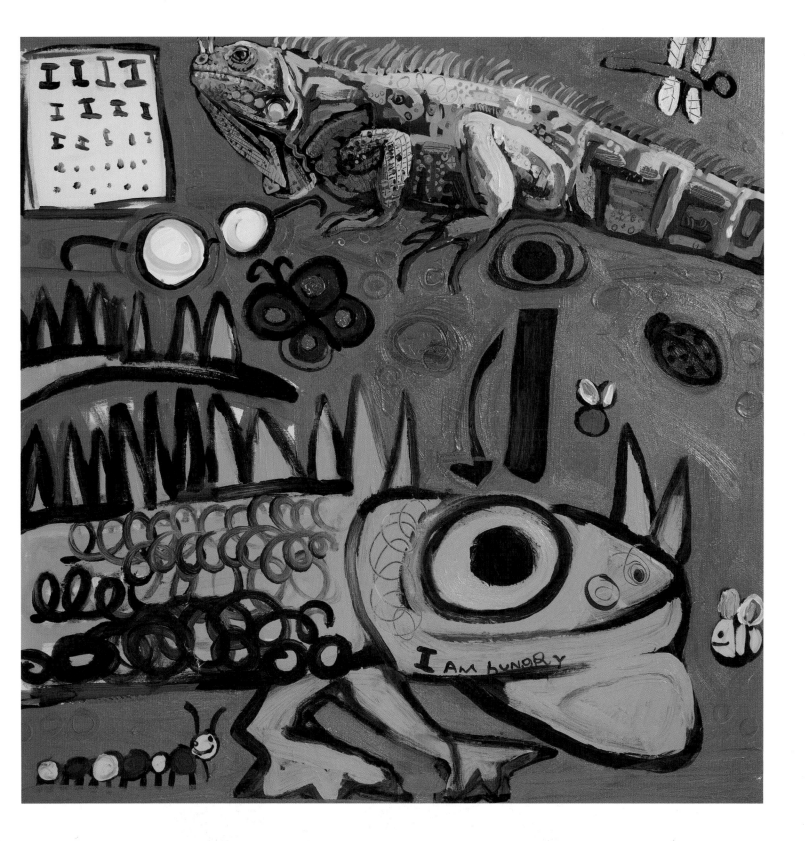

Those are some
Joyful Jerafs.

J ISN'T FOR GIRAFFE!

IT IS IN SPANISH!

AND WHY IS THE J BACKWARDS?

THAT'S JUST HOW SOME KIDS JOT THEIR J'S!

FAIR ENOUGH! WHO AM I TO STAND IN THE WAY OF FREE EXPRESSION?

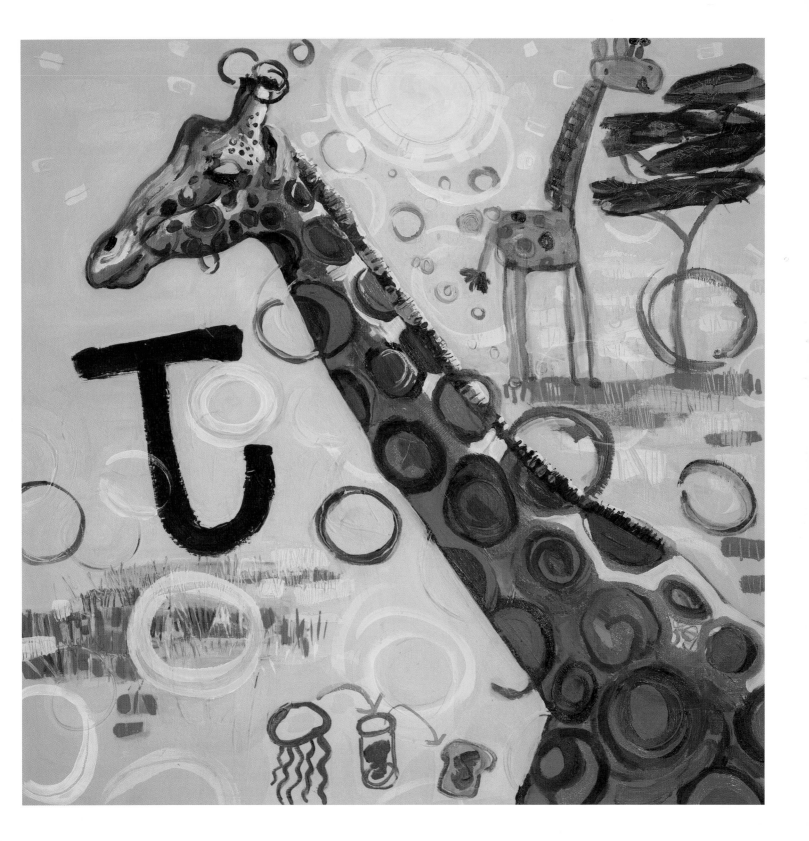

Knock out!

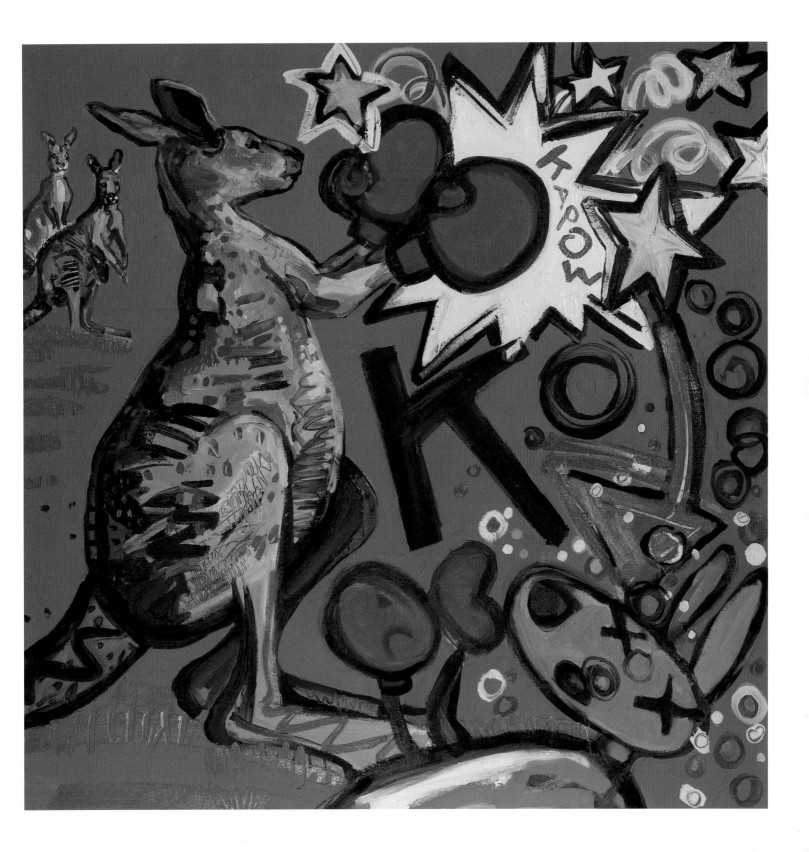

L-a-fents **L**OVE **l**ollypops.

MORE LEGAL JARRRRGON

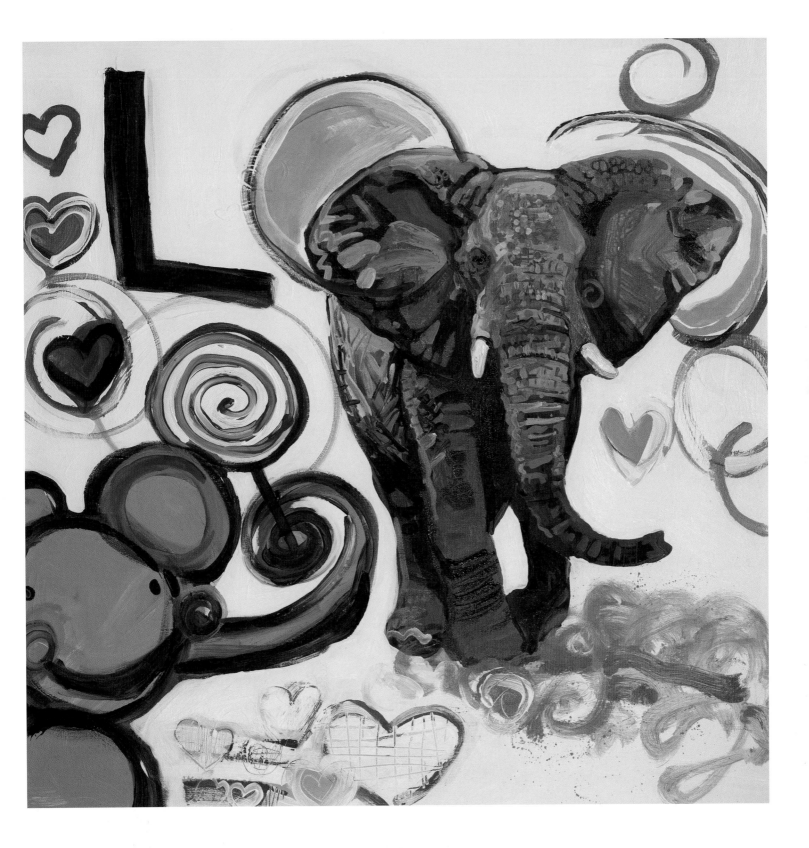

The **m**oo-cows
are very **m**otivated.

DON'T YOU MEAN MOO-TIVATED? HAR HAR HAR HAR HAR!

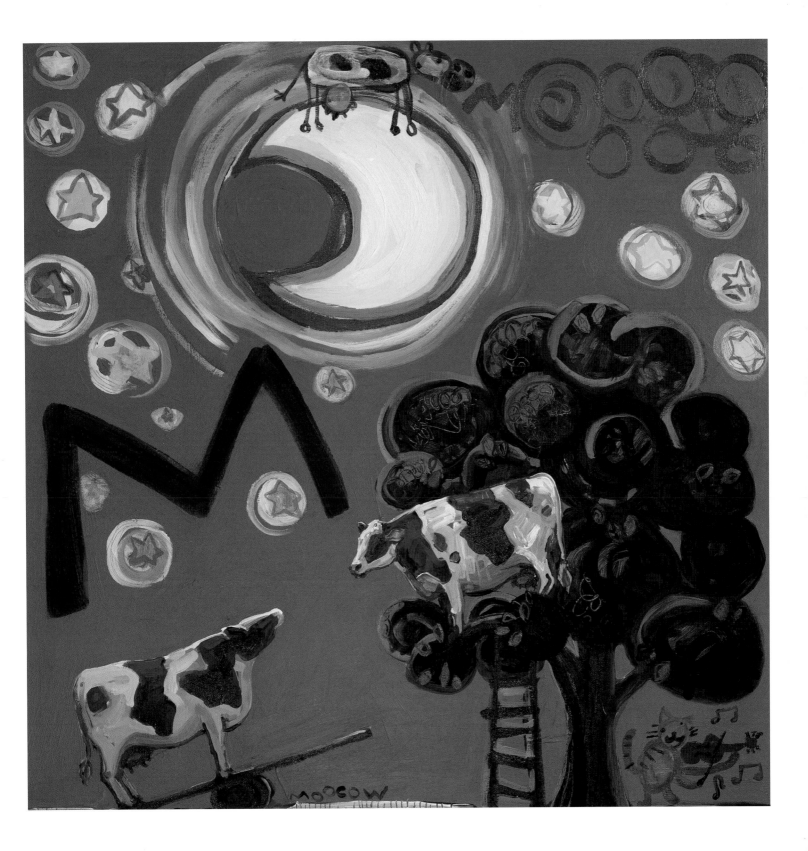

No! Narwhals *are* real.

NARRRRRRRWHALS! THAR SHE BLOWS!

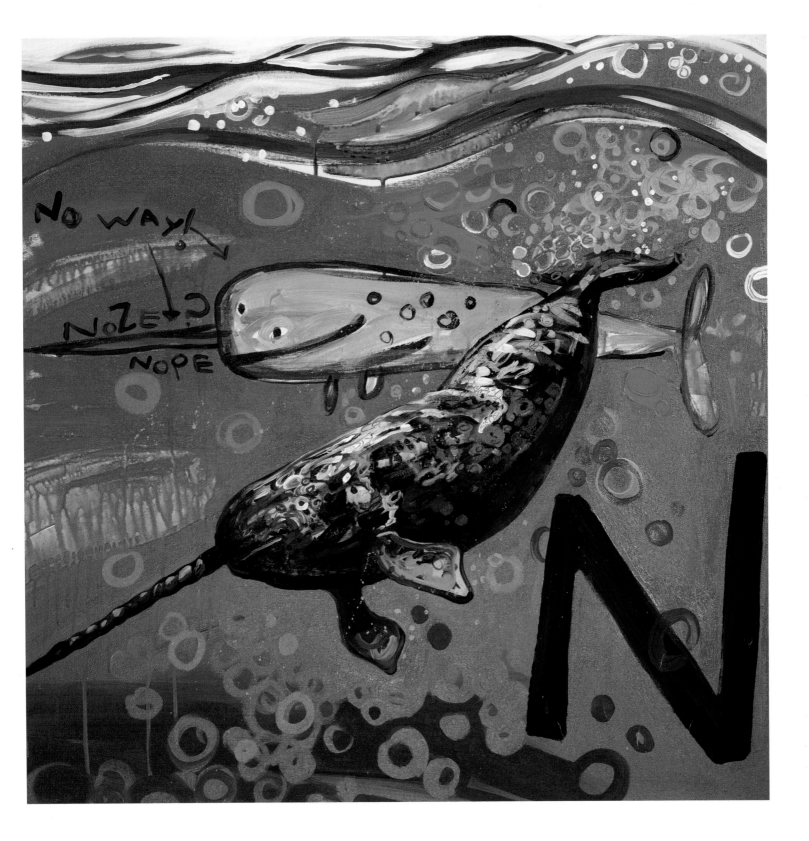

Oh my,
a lot to observe
for one owl.

THAT THAR BE AN OKAPI AND AN ORANGATANG AND AN OSTRICH! THAT THAR'S AN OCTOPUS! ODD!

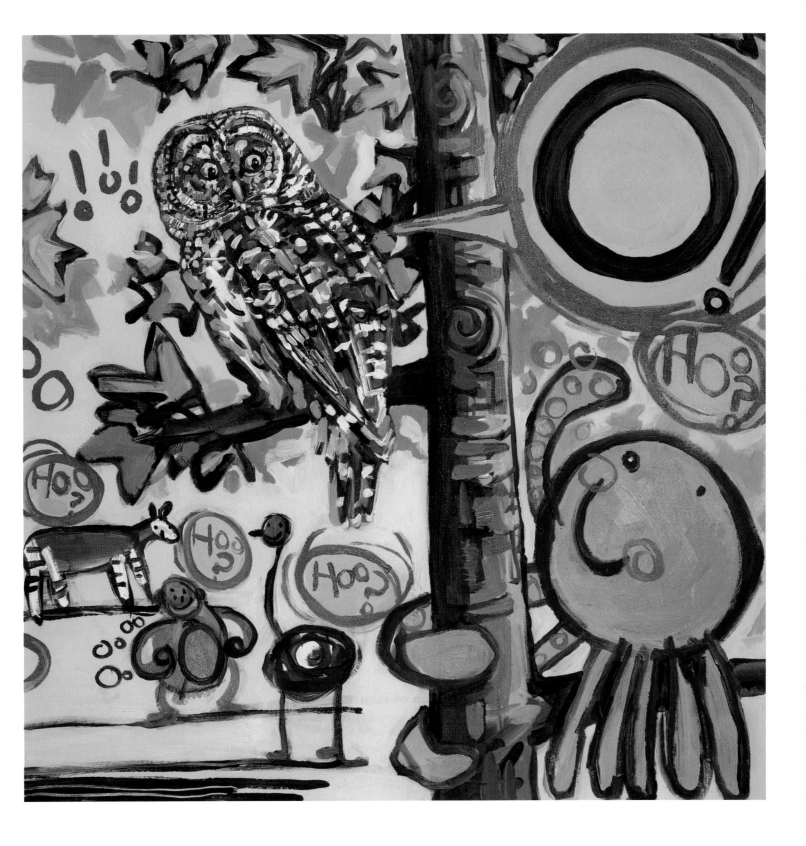

This little **p**iggy
went wee wee wee wee
all the way home.

WEE WEE, PEE PEE SAME THING! TIME TO SWAB THE DECK!

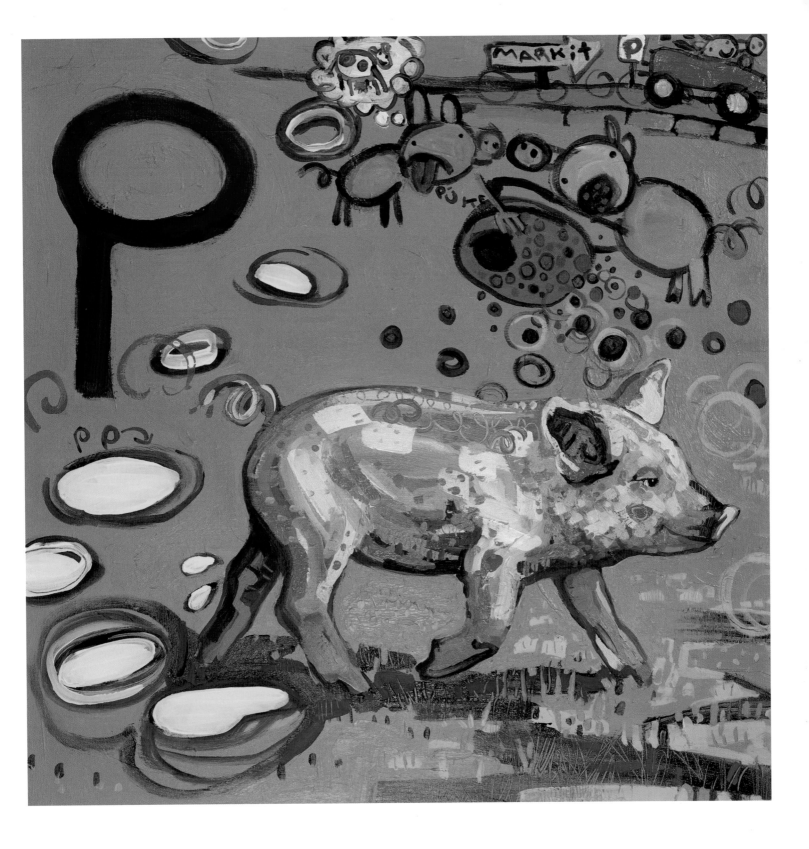

Quails (and a **q**uetzal) standing in the **Q**.

YOU'RE QUAZY MATEY - IT'S A QUEUE!

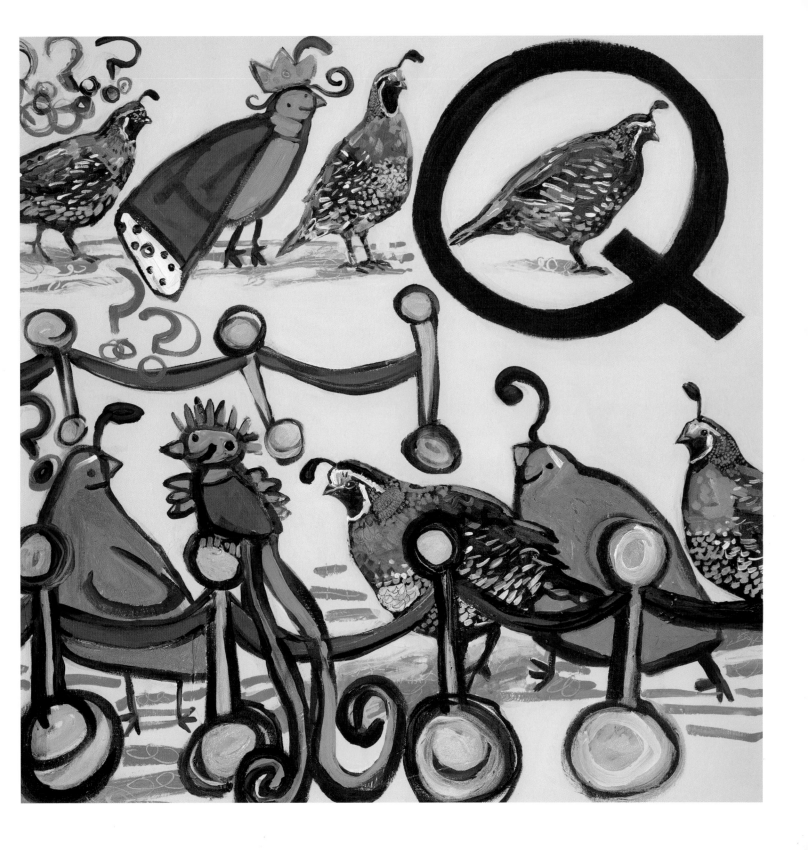

Rinkly Rhinos (and a roving random rogue).

"RINKLY IS REALLY SPELLED WRINKLY EVEN THOUGH SILENT W'S ARE A WHOLE LOT OF RIDICULOUS."

EVEN MORE Legal Fixes

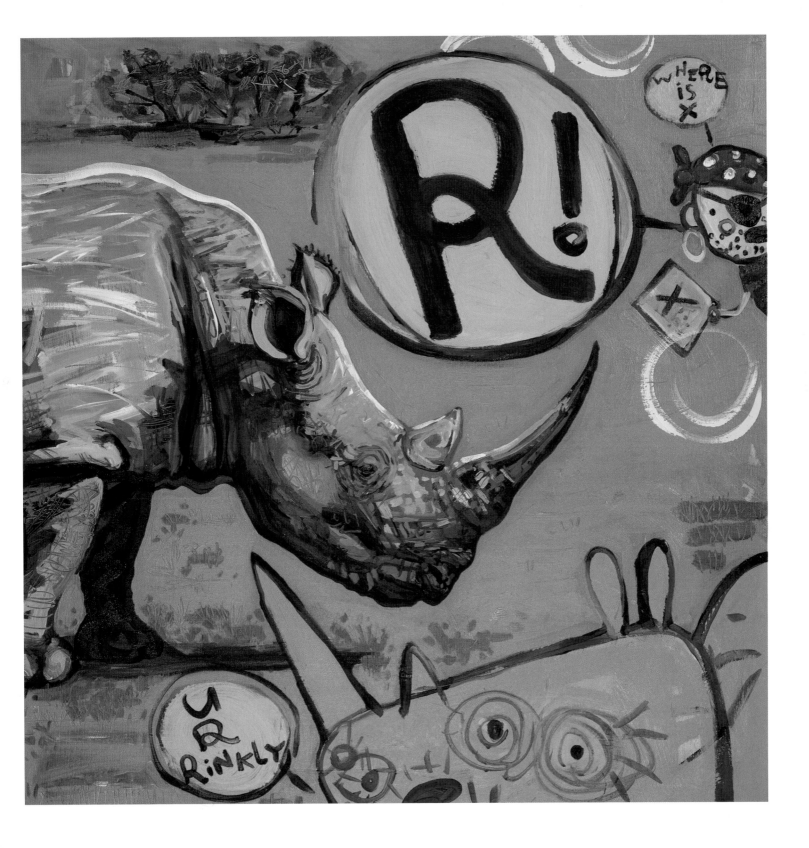

Sea horses are not simple to straddle.

THAT'S SOME SIZE-SHIFTING SILLINESS!

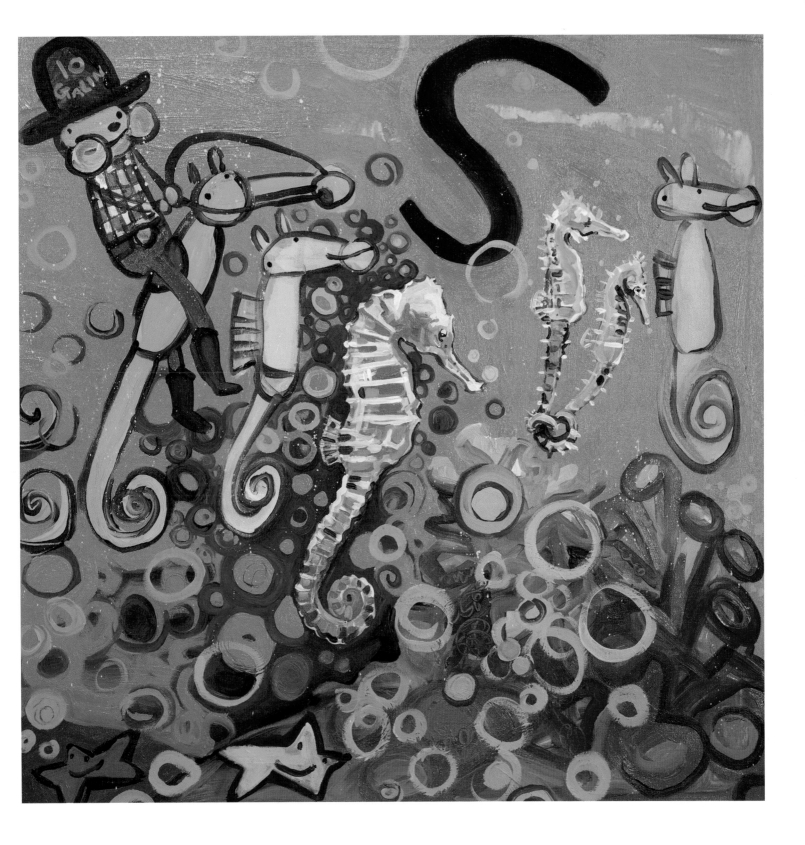

Tiger has
a totally different take
on t-time.

TEA, TEE, T! IT'S TOO, TOO MUCH!

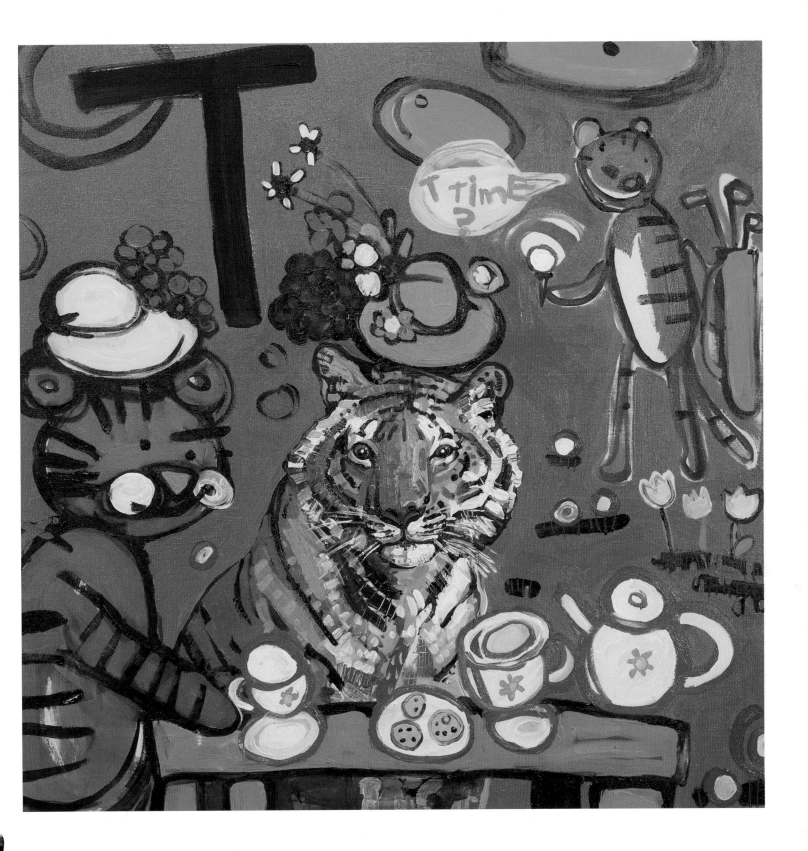

Unicorns love riding **u**nicycles **u**nder **u**mbrellas.

UNDER WHERE? HAR HAR HAR HAR HAR!

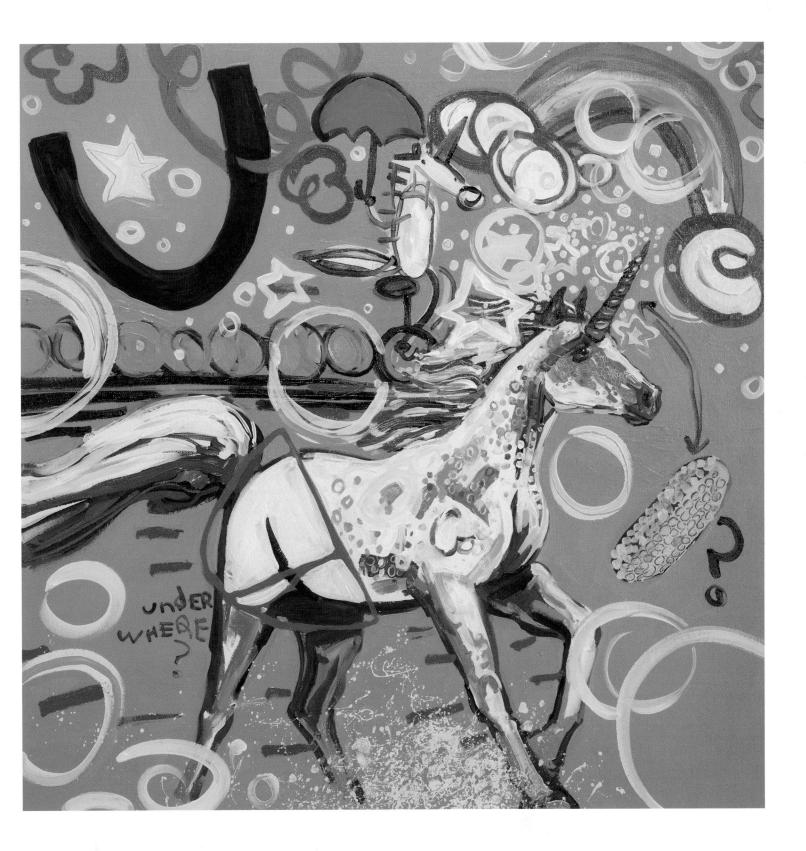

Vampire bat vernacular with viper violets and vulture vegans under a variety of balloons.

PIRATES ALWAYS EAT THEIR FRUITS AND VEGETABLES – IT FIGHTS SCURRRRVY!

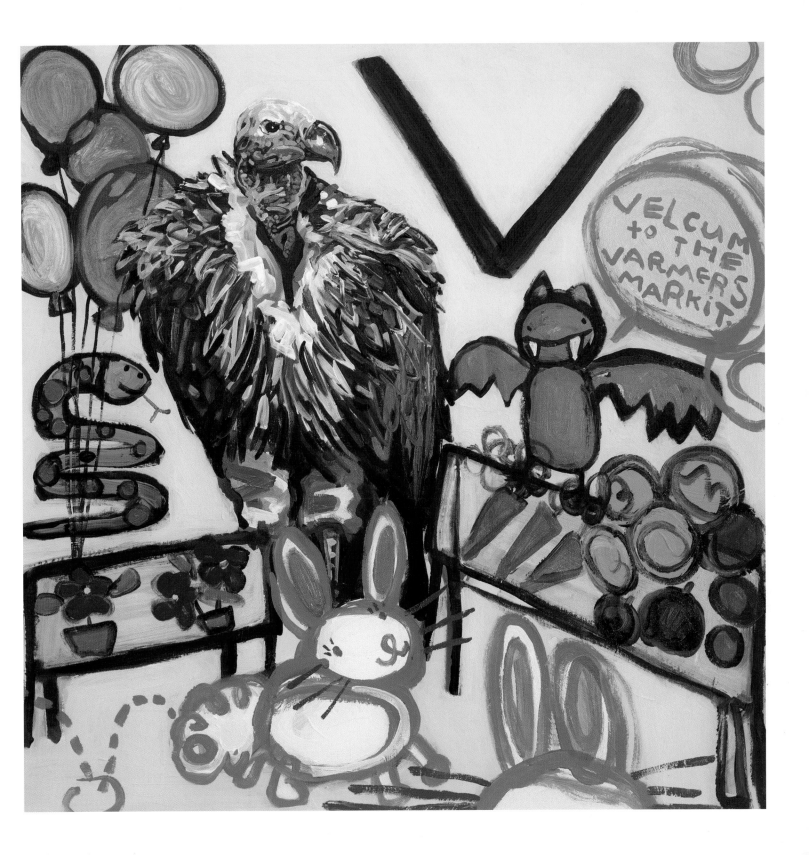

What Red said.

SERIOUSLY, DID THE WOLF THINK HE'D PULL THE WOOL OVER HER EYES? WACKY!

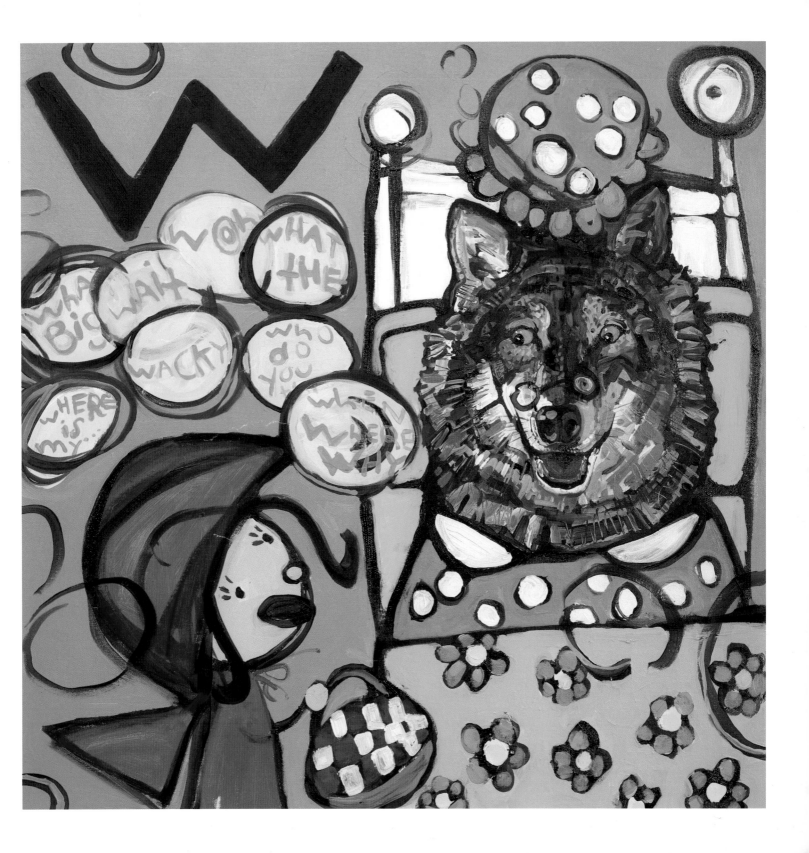

X O **X** O **X** O and
a fo**x** on a bo**x** with an o**x**.

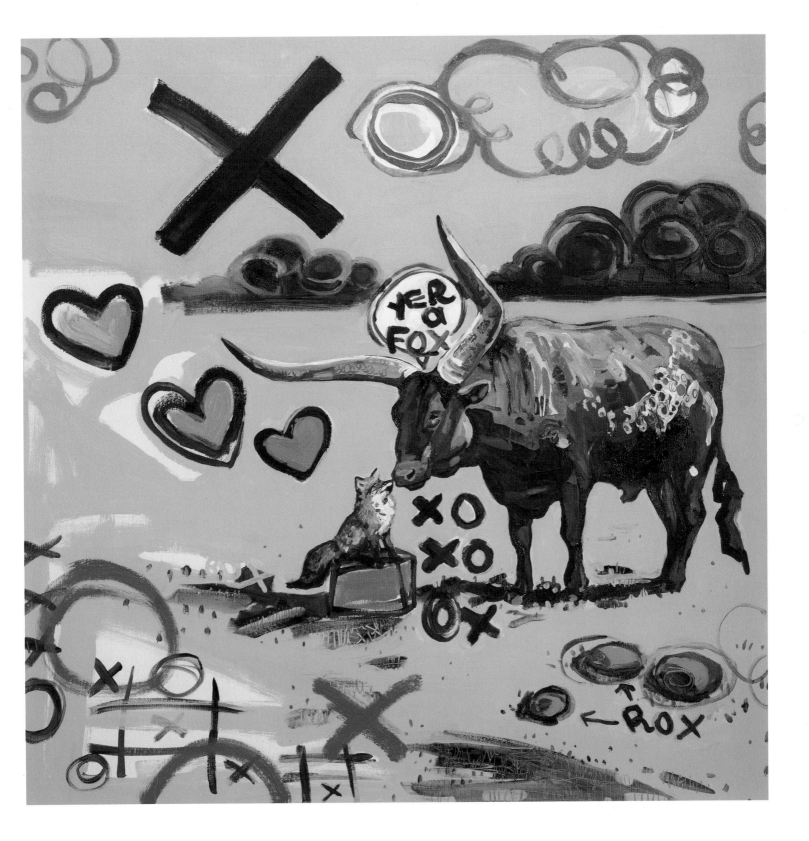

Yaks on a **y**acht about to...

YIKES! YOU NEED TO GET YER SEA LEGS!

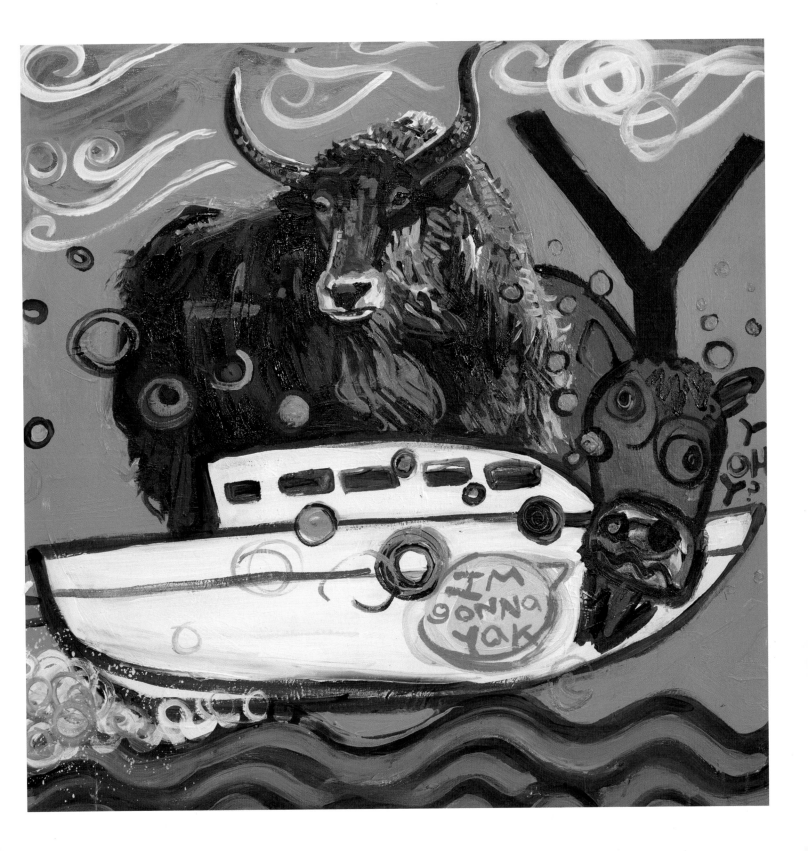

Zebras **z**ip
into **z**omething different.
A **z**oot suit maybe?

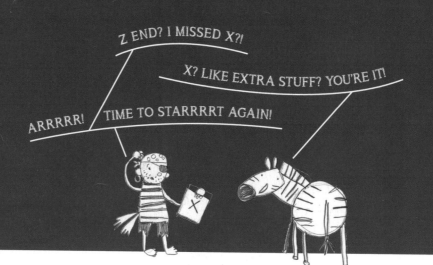

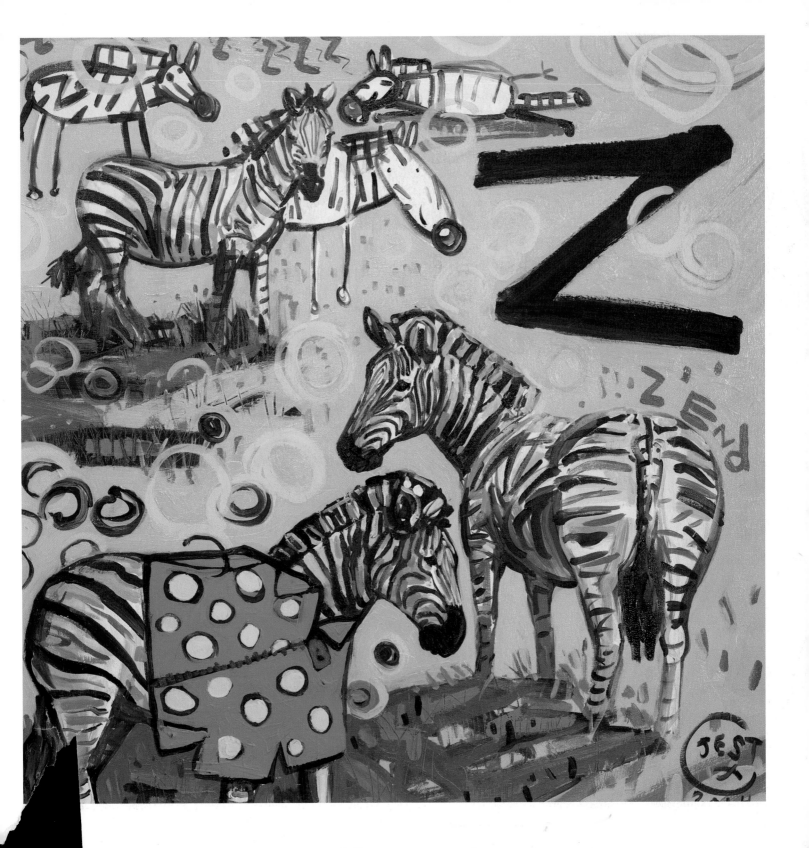

Book design by
Scott Millen at 2 Fish
Company, LLC.
Project managed by
the Rev. Jim Daniels.
Project funding by
awesome people
through Kickstarter.